THEIR SILENCE A LANGUAGE

JEREMY HOOKER
and
LEE GRANDJEAN

Their Silence
a Language

London
ENITHARMON PRESS
1993

First published in 1993
by the Enitharmon Press
36 St George's Avenue
London N7 0HD

Distributed in Europe
by Password (Books) Ltd
23 New Mount Street
Manchester M4 4DE

Distributed in the USA
by Dufour Editions Inc.
PO Box 449, Chester Springs
Pennsylvania 19425

Text © Jeremy Hooker 1993
Images © Lee Grandjean 1993

ISBN 1 870612 23 X (paper)
ISBN 1 870612 28 0 (cloth edition, limited to
25 copies, signed and numbered by
Jeremy Hooker and Lee Grandjean)

The text of *Their Silence a Language* is set
in 10pt Ehrhardt by Bryan Williamson, Frome,
and printed by Antony Rowe Ltd, Chippenham

Contents

Wind sweeps over Wilverley Plain 9
Went in the rain to Barrow Moor 10
'Bolder Fountain' 11
Steps 12
Walking all day in the Forest 14
So the Old Snake Sheds its Skins 15
Fallen cliffs, breakwaters 16
'Ladder' 17
Black on Gold 18
From the train 20
'At the Core' 21
First Touch 22
Opening 23
Once, deep in an inclosure 24
Stepping in 25
Clearing 26
A Forestry Commission notice 28
Dark on the open plain 29
Ytene 30
One tree, a beech 32
Variations on 'From' 33
'From' 35
'Step's Flame' 37
Over rounded gravel hills 38
'Elusive Spirit' 39
Elusive Spirit 40
Druid Song 42
Stinkhorn 43
Ponies standing 44
'Silence' 45
Alder Song/Lines to M 46
The winter woods 47
Walked alone in light misty rain 48
'Company' 49
On the Road through the Forest 50
We were looking for the Eagle Oak 51
Oak Song 52
At Queen Bower 54

The Cut of the Light 55
The pattern again 57
Red King's Dream 58
Company 60
Where the Gorse Fire Was 62
The Naked Man 63
Present 64
'An Unknown Way of Being' 65
Windless Leaf-fall, with Emily 66
'Wind Fall' 67
Blackened furze 68
None of the greater 69
In Stillness 70
Almost Nothing 71
The Naked Man 72
'Naked Man' 74
At the Edge 75

For
Mieke and Kate

Wind sweeps over Wilverley Plain and the matchstick chimneys by Southampton Water. Trees, which lean permanently away from the sea, bend further.

Masses of broken cloud pass over. From far off, bright-dark, shadow edges sweep towards us. Stones and a grey pony stand out, white as the shadow crosses and the sun catches them. Shadow of my hand on a white page.

Went in the rain to Barrow Moor and walked toward Mark Ash and Bolderwood. ('Bolder' is Anglo-Saxon for house, but is this the same word as the name of the river, 'Boldre'?) Followed a small black stream, grass vividly green around it; but difficult to get through the boggy low ground, and on the dry higher ground, bracken was more than head high.

Warm, slightly sweet smell of decaying leaves. Giant beech torso – the dead tree a new world: encrusted with several fungi, furred with moss, small trees and plants growing out of it – birch, rowan, bramble, fern – a home for insects, animals, birds; its roots like a large fragment of clay and pebble wall. Pieces of eggshell on the ground: so fragile among windfall sticks, under massive trees, but with their part in the immensely strong life continuing season after season. In a wood of old beeches the tree in its upward flight and cascade of branches is like a fountain beside the earth-bound oak.

Walking back, I felt a sudden brief fear when momentarily 'lost' – in fact, yards from the road, which was hidden by bracken.

STEPS

First is the feeling,
which I must trust, moving on –
cut into the void.

*

A passage opens –
that is where the drama is –
out of the covert.

*

To attain a truth,
work fearlessly, for ourselves.
We must break our taste.

*

You dance on the edge
of destruction, you dare see
what will come of it.

*

There is work to do
with fire – simplify the self –
charred and blackened form.

*

You finger the edges,
you execute the instant –
gallows-carpenter.

A rooted figure,
bound to earth but gesturing
at the open sky.

*

A human forest –
energy between figures,
linking them and us.

*

You shape the image:
it is a bridge we cross over
to meet in the world.

*

To know oneself shaped,
and work with knowledge of death –
that it may bear fruit.

*

Fern, gorse, pine, slow cloud
moving on – 'voice of the rhythm
which has created the world'.

*

One use of space is
for speaking across, another
to deepen silence.

Walking all day in the Forest, I saw again how impossible it would be to convey a true impression of the ancient woods of oak and beech without showing that they are movements of light and shadow and air as much as countless tree-shapes; or rather that the natural 'pattern' continually changing around one comes from the interaction of forces and things which together make a world of the most delicate and subtle movements, and strong, deep-rooted forms. And this is only to sketch the surface, without regard to the interdependence of growth and decay, or of the many forms of life each with its own world in the world that human senses perceive; as for example insects under a scale of bark, a grey squirrel leaping from tree to tree, a woodpecker crossing a glade.

SO THE OLD SNAKE SHEDS ITS SKINS

Clash of flint with flint
that waves hurl against chalk

Risings, sinkings:
cycle on cycle

Fresh water, salt water,
brackish lagoon

Whirl and loop
of streaming gravel

Cloud on cloud of sediment

Yaldhurst: the tilled fields

Fallen cliffs, breakwaters – rows of stout posts standing out above the sea – gravel, gorse to the very edge of the cliffs: these things move me strongly.

They belong to love and friendship. Being with J at Hordle gave me the beginnings of a poetry that was really mine. The posts are vaguely human in shape and they stand for a massive effort that is only temporarily effective and has to be renewed over and over again; and at the same time they are completely non-human, insensate, and like a strange thing emerging from the sea. They belong and do not belong, they become part of the sea against which they are a defence, the waters they are meant to break.

A sleeping painter and a sleeping sculptor come awake in my senses there. When I come back the smell of the sea is on my hands.

BLACK ON GOLD

He dreams he is a painter standing
at his easel in an ill-lit attic painting
studies in black and gold.
A dead butterfly flutters in a breeze,
dances at the window in a filthy web.
Even when I was a boy (he thinks)
walking with a rod in April among the trees
I tasted filth. How free the mind?
A man – but what (he asks) is man? –
will do anything not to wake up.
He dreams he is a sculptor hacking
at the block that is himself.
It is black, black as rainwater
from the stump of the tree of knowledge.
Let me let in the gold (he weeps)
but the wood rots under his hand.
He dreams he is a poet writing
a poem about the shadow of a tree
leaning over water, where sunlight
touches the gravel bed with gold.
He is losing his bony grip,
the bank is eroding under him.
Wild bees swarm in the hollow of his skull.
He dreams he is a hunter chasing
the beasts that seek him.
On hands and knees, belly
dragging in mud, icy skin,
he follows where a black stream
runs through bracken into the wood
and a doe steps gracefully to the brink
and bends her neck and drinks.

From the train: dark, bedraggled gorse bushes, dripping birches on the heath, shockheaded oaks. Trees drawing the dusk down, gathering it. Light in pools of water.

I am conscious of being drawn to the same few things again and again, and of seeking images of the life in them. Does this mean that I want to relate to the things, instead of capturing them? Or to elements that endure? Is kinship what I seek?

Perhaps there are many motives for an apparently simple act of naming or image-making. And continuity is one of them. I have no sense that a nostalgic haze colours the Forest as I look out on it. Nothing could be more distinct than the quality of dark or light, or the wet bushes and trees, or Sway Tower as it disappears behind the ridge at Marlpit Oak. I see what I have always known, and feel the things with a child's touch, and because I am passing through.

FIRST TOUCH

A breath,
a touch of air
that feels so gentle,
so light,
on curve of wing and leaf.

A spider
poised on silk
which binds the furze.

Skaters
making circles,
dimpling the stream.

A fly
borne down
turning and turning.

Touch of the god
with broken hands
who rounds the globe of dew.

OPENING

A butterfly alights
on a bramble flower

in a clearing in the woods,
and opens its wings wide,

trembling. It does not see me
apart from the trees, where

I stand watching silently
as it flies to another flower,

opens its wings wide,
and with a tremor, sips.

It is silver under wing
and above, bright orange,

almost gold, against
the leaves' darkening green.

Later I can learn the name
we have given it, but now

I only watch, tasting
the pleasure that it gives.

Once, deep in an inclosure were several deer, nervously holding up their sensitive heads to look round and sniff the air, then, with a start, vanishing. Later, at the edge of an inclosure near the railway line we saw four more, and this time got closer. A train passed noisily and they took no notice, but at last they saw us and started away again. Arriving quickly where they had been, there wasn't a sign of them, only the silent trees reaching back into deepening half-light.

STEPPING IN

Unseen by the human eye,
hosts swarm, in the air,
in the earth, under bark.
Every dead thing renews
the fabric; oak walls grow.

Each footfall disturbs
a community. The wolf spider
hunts over leaf litter
which is his dancing floor.

This is the house
the sun builds, with air
and water and the green leaf.

Gods have thundered and passed on,
rustling the canopy.

CLEARING

*'You are now your own carver, and must be
that which you shall have made of yourself.'*
 William Law

1

There are places in dreams that frighten me –
ruins at which I dare not look back.

Once, on the heath, a tower,
white as salt, with letters in gold,
cut high up on the face –
ancient laws, which I had no time to read.

I stood at the edge of the heath
with the tower behind me.
In front the ground sloped away,
and fell, and there was nothing.

It was where a dream ended;
where a dream had yet to begin.

2

Deep in the dark
an eye of white shows through.

I cut at brambles that clutch at me.
Holly slashes the back of my hand.
A branch like a tusk gores my side.

Stumbling on rotted wood,
breathing pollen and spores,
blindly I hack a way in.

Suddenly the dense underwood
springs apart, and for a moment
there is a clear space at the edge
where a figure stands –

a boy who whittles a stick,
a man who tests a blade against his skin,
a bone sculpture with blood running down –

But already the ground falls away,
and falls, and there is nothing.

A Forestry Commission notice informs us we are walking on a track that goes back to the Bronze Age, and, much later, was probably a smuggler's way. As we walk on it, between the Plain and a sweet-chestnut plantation where a starling is whistling and small birds are singing, a large, military helicopter, with rotor blades at the back and front, circles widely and noisily overhead.

Smoky blue bugle among young ferns, unfolding or hooped, like tender green hooks fastened to the earth. In the open, an old hawthorn blossoms, trunk rubbed smooth, with grey horsehairs clinging to it.

Dark on the open plain, a holly 'hat'. (J. R. Wise, the historian of the Forest, was certain that the word, which here replaces 'clump', originated from the high-crowned hats of the Puritans.) Dark green hollies, their lichened trunks a lighter green – sombre, without berries. Nearby, scattered silver bones of furze branches and stems. Nothing in the Forest seems more enduring than holly and twisted furze.

A strong wind was blowing across the heath – we could hear it roaring in a distant inclosure of pine trees. Over the pines, in good light, the view leapt to a whaleback of Island downs. Grey cloud was blowing over, with brighter, bluish-white depths where the sun almost broke through. Shallow pools of water lay on the heath, and the soggy grass and moss squeaked under our shoes. We crossed a broken concrete runway and walked to Ocknell Pond. Here wind was brushing the surface violently; it was just as if an invisible besom was sweeping across it, and with sudden, more violent strokes, making the ripples fly in an arc, skittering wildly, as fry scatter in panic before a pike.

The wartime airfields are haunting places. It is hard now to imagine any of that – Hurricane squadrons, Mustangs, Wellingtons and Liberators, gliders and practice parachute drops, all the makeshift life of encamped airmen and soldiers – where cattle and ponies feed among furze and the runways are minor roads. So much of that was, to me, a romance anyway, divorced from the emotions of the fighting men, set down in a place which must have meant to them something that it did not mean before the war and has not meant since.

YTENE

I fling myself down on the heath,
I never felt more alive –
grass pricks my back,
sun on my closed eyes.

What knowledge hides from me
in the bones of gorse?
Their tough stems root
in the ashy soil of barrows.
They fissure concrete runways.

I might be a Jute, weary
from the sea from which I turn,
the waste before me
the edge of a new world.
I am an exhausted airman
between sorties, resting
beside the airfield cut from heath.

How close the knowledge is
which every thing conceals.
The adder coiled on a sandy bank
is its sign; it is what
the stonechat chacks.
Butterflies flutter round
with some great purpose.

If I look hard, I must see it –
the ridges, the rolling waves
of moor grass and heather and ling
are a seaway with a destination.

Is it death
that is bodied in the bleached stones?
Does death grow down into the acid soil?
It is not death alone.

I am thirsty from walking in the heat,
but when I have drunk,
and lie down on the grass,
it is what I don't know that parches me.
I am the waste the gorse roots in.

(*Ytene, an early name for the New Forest, has been said to mean either a furzy waste place, or the country of the Jutes.*)

One tree, a beech, held us for a long time. The trunk seemed to consist of limbs, bigger than an elephant's legs, grown together, twisted, and as if moulded from lava or some grey metal. It had grown bosses, like worn-down gargoyles, and many initials were carved in the bark, from near the base to a height only climbers could reach. Some were recent, others older: EH 1921 (partly obscured by moss) RW 1920 and, the earliest we could see – or believe – EH 1907. Others, including a heart, had been almost completely grown over.

They reminded me of the initials scratched on the limestone wall inside Winchester Cathedral, some of them dating from the sixteenth century. How long would initials cut in wood last? Some of these, well-cut, had probably lasted longer than a lifetime.

Tiny, delicate wood sorrel were growing among the roots and a long bramble hung down from a fork. In spite of dead branches and internal decay, the beech had a lot of life in it.

VARIATIONS ON 'FROM'

He lifts up his shell
over his back. Does he know
what he is made of?

The shell feels like wings.
He tries to flap them. The wood
grows harder round him.

*

His body holds fast
to the earth. Yet he is, too,
a bow bent to shoot,

and the soul's arrow
drawn back, alive to his touch
in every feather.

*

His body's a bird
made from the bough it sings on.
His wings are the sky.

*

He hangs gracefully
like a hawk preying. Behind
him, poised, his shadow's

a man crucified.
Soon he will stoop and drop down,
blood spit on the earth.

*

Sometimes when earth opens
he grows into her.

He becomes sapwood.
His kin lodge under his ribs.
What is the thing men

boast of? His head shakes:
Man is branded on his brow.

*

He is always that
which he is about to be.
Now as he emerges

from the wood, he is
the tree walking, the passage
that will be his way.

Between earth and sky
his body stretches. He strides out,
and earth underfoot

thrusts and pulls. His flanks
are downland curved on the sky.
He is flame also –

wildwood flickering,
blazing through trunk and limb,
burning in the mind

of the maker carving
him, consuming dead wood,
shaping him anew.

Over rounded, gravel hills I followed a white (leached-white) path that became a pony track through heather and bracken, expecting at every careful step to tread on an adder. Yellow and rusty gold bracken among purple and green, its skeletons crushed underfoot. Bright gorse flowers on young shoots, close to the ground. In the valley bottom, near the first trickle of Avon Water, I walked along the abandoned railway track and crossed to the edge of an inclosure.

Sweet chestnut, including a fallen tree with dead branches among branches thick with leaves and prickly coated fruit, birch, beech, oak, alder where the ground was boggy, firs and colonies of orange toadstools. I saw a grey squirrel, a dark butterfly flying up fast and high, magpies, a rabbit among gorse bushes, and heard and saw a green woodpecker. Play of light and shadow, movement and stillness, among leaves and branches and ferns: the quick and elusive spirit which the solidity and darkness associated with woods belie.

Out on the heath again. Dark blue cloud masses, blue sky, revelations of the sun. Now, coming over the brow of a hill, a sudden burst of sunlight at my back flooded past me, and, with it, a fine rain blown by a wind from the sea. Before me, a rainbow, one foot apparently on the heath, the other lightly touching a distant wood.

ELUSIVE SPIRIT

What is the quick, and where
is the spirit that eludes you?

There are rumours that seem
to speak of it here:
prickly fruit on a fallen tree –
dark butterfly that whirls up
fast and high, out of sight –
tap tap tap on dead bark,
the yaffle that flies away
crying his ancient laugh.

What stands revealed
for a moment, naked
as nails struck into wood?
All that hardens, dissolves,
dissolves and hardens.

Light stabs through clefts.
Hollows cup dark, in which creatures
that crawled from the sea bottom
millions of years ago
live on decay, enable life.

Even as you look, all
that appears solid transforms
root and branch.
 Where
with a word you nailed down
that quick and elusive spirit
there is a flicker, a rustle, a sudden
sword dance of one bracken frond.
Dark whirls up with dead leaves
in a gust of sea wind, sun pours
where the trunks stand still.

DRUID SONG

Who keeps the vert and the venison?
Who calls the creatures into a circle?

The stag-headed one,
bearded with green leaves,
lies down with the tree that was windthrown
 in its prime,
the lightning-shattered,
all the litter of the seasons.

These come again –
 new wood, timber.

But Thor's tree is down,
the groves of the oakmen are felled.

There is no leaf, no twig
that does not grow upon the tree of life.

Where is the tree that will rise
to lift up the image of its maker?

STINKHORN

In one version the mother
mocks him for his pride:

Maker, Master of all things,
ramping where stags have rutted –
who laid the egg from which you burst?

Lord among creeping things,
your white flesh waxes and withers;
your stink attracts the flies.

Phallus Impudicus,
erect among leaf-litter:
what do you think you are –
Old Cock of the woods!

Ponies standing utterly still at the wood edge, as if listening to the stillness in the air.

From open heath with Scots pines to ancient beechwood, with a few oaks and an understorey of holly and dead bracken. Sun sharp on holly leaves, shining silver; sometimes an older holly is completely hollow, like a tree in cross section or a reed that a boy has cut with a penknife and scraped out all the pith.

A soft floor of bright green moss and brown leaves over black leaf-mould. Black damp stains on trees. At a little distance, in half-light, a stag! In fact, a fallen beech, its up-ended roots forked and twisted. Everywhere, tree gargoyles – ape or devil, an elephant trunk – but the real mystery is that trees are completely other.

Grey stillness of beechwoods, like the ponies' stillness, as if listening, or communing silently in a mode unknown to us.

ALDER SONG

Alder carr
coppiced
by Avon Water –
as if to say
Water Water,
because one word
is not enough?

But these alders
long ago outlived
their human use,
and now grow simply
to be near water –
Water Water –
what word's enough?

LINES TO M

Crushed bracken fronds, where we lay.
(Remember the nightjar's churr.)

Dry river-bed through the woods,
Torrent of stone, tumbled and stilled.

The winter woods, you say, are a ruined cathedral. A downy feather falls between bare branches like a snowflake. Wood bleeds slowly from dead trees becoming earth. Suddenly, thousands of pigeons rise from the floor and fill the empty space with wild-beating, blue-white flashing wings.

Walked alone in light misty rain in ancient woodlands. 'Mystery amid a great company of tree,' as Heywood Sumner wrote. No one else about; only a few birds, mostly small flocks of finches, and all silent; a couple of ponies where the trees gave way to heath.

Great oaks and beeches all round, some oaks massively bossed and knarred; many fallen and twisted and broken in countless beastlike shapes. Easier to describe than human beings, of course; but difficult to write about without the usual clichés. It is their own life that fascinates me, and the processes of death and decay and new growth in the woodlands; but man's life has been so intricately interwoven with them, and still is in our language, that I find it almost impossible to talk about trees except in terms of resemblances to humans and other creatures. The strength in them isn't in their weight and bulk and stature alone but in their tremendous resilience, in all the wounds which oaks in particular simply grow round. And as I saw it today, the wood was full of wounds, it was a place of fearful, violent rendings, and of great patience and endurance.

Trees, more than any other living thing, have been our servants, but there's nothing domesticated about ancient trees in a wood. I'm tempted to call their silence a kind of language, but know that I'm only attempting to catch the impossible – an unknown mode of being – in words. For although we know what they are, and can analyse all their parts and principles of movement and growth, I always have the feeling that they *look out*, with a 'knowledge' and 'vision' completely different from ours, who look in at them.

ON THE ROAD THROUGH THE FOREST

All day all night
the carnival – pheasant

like an Indian head-dress
scattered on the road;

small birds tarred
and feathered; a fox

rubbed out, erased
to the last red hair

in grit, under our tyres;
soft thud of rabbits,

dancers with broken backs,
and in the woods,

in some nomansland
of the spirit, a smell

of petrol fumes; dead
embers of gypsy fires.

1

We were looking for the Eagle Oak (where the last white-tailed eagle was shot, in 1810) and, not for the first time, failing to find it. Above tall, slender Douglas Firs, which created a sense of space, a sea wind was dispersing cloud, and as it strengthened and freshened, we were reminded how much sea winds are part of the forest, influencing and even to some extent shaping it.

'We're walking among eddies of water.'
'We're eddies of water ourselves.'

2

'Hold the tree in your mind,' he said. 'The roots are the past, the trunk is the present, the branches and leaves are the future. Hold it all together in your mind.'

We were drinking from cans of guinness, sitting under a great, half shattered beech, which had been struck by lightning. On one side it towered above us, strong graceful limbs in a spray of green leaves. On the other, there was a charred hollow where half of the tree had been struck down, leaving the wood gouged and splintered. We sat on a stricken limb and other fragments of the shattered half lay about us. Already the blackened hollow was nourishing new life.

I thought of Traherne's Jacob's Ladder: the Cross which is a tree set on fire with the flame of love, and illuminates the world.

3

'Once on a leaf or needle, acid rain disrupts the operation of the stomata, the tiny openings that permit a tree to "breathe". The process of photosynthesis is thrown off balance, and subtle changes take place in the internal chemistry of the tree that result in discolouration and premature aging. Finally, acid rain washes away vital nutrients from the leaves and needles so that the tree slowly starves to death, its respiratory, circulatory and "digestive" systems crippled. When death comes, it is often due to natural causes – insects, high winds, frost and drought. Much like an AIDS victim whose immune system has broken down, the ailing tree is left defenceless against the ravages of nature.'

(*Time*, 16 September 1985)

OAK SONG

for Carl Major

Oak
 at the back of the cold

after sedge and rush and Arctic birch
before the thief of fire
before the information of the axe

Noah's oak, laid
in drift gravel
with mammoth tusk

Black rings burnt in the soil

 *

The lover of the tall stag
also appointed concerning the hares
that they should go free

The rich complained
the poor murmured

How sharply the man
in the covert sees
threatened with blinding

 *

Skin for hide
skin for bark
nailed to the bloody tree

 *

Oak
>for the makers of cruck and hull

Pickings of useful parts
knees and elbows
from doddards
though the body be decayed

'Caste acornes and ash keyes
into the straglinge and dispersed bushes:
which will grow up sheltered,
unto such perfection
as shall yelde times to come
good suplie of timber.'

>*

Saviour, protector, bearer
of the world's wealth –
stripped from the forest
that favourites crawled on,
leaf-rollers, baring the crowns

>*

Stacked, loaded
at Southampton Docks
for the trenches –
painted by an English Cubist
sharpening his vision

At Queen Bower, following the stream through the woods, I saw the heath blue as smoke in the sun.

Water dark green where deep and shaded; ochre, yellow, gold where the sun came through, lighting sand or gravel shallows; a most beautiful transparent green at the point of shelving and darkening. Pulse of reflected water-light on tree trunks, and below, a procession of bubbles and fragments of foam curling in an eddy, ceaseless corrugation of rapids, infinitely various shapes of branches and sky mirrored in still water, and the currents sinuous as eels. Sun splintered in countless glittering points, or its image held full and gleaming white, like a bright moon.

Returning to the stream from an excursion across an open space, I saw a herd of deer: white rumps and tall antlers moving peacefully between trees, not scenting me, perhaps, yet looking in my direction and apparently at me, without fear, but keeping half-hidden and well out of reach.

There if anywhere it's possible to see only what the Normans would have seen. What would a Saxon feel, even if about his lawful business, when caught up in the woods by a hunting party? Like a hare in hiding, perhaps, when huntsmen and hounds rush past on the heels of a fox.

Tree fallen across the stream, like a giant spider. Heywood Sumner quotes Percival Lewis writing, in 1811, about the oaks: 'They do not grow to any considerable height, as oaks usually do in richer soils, but rather extend their branches horizontally, and in most irregular forms: the consequence that results from it is that the timber is more particularly adapted to what shipbuilders term knees and elbows, and on that account becomes more valuable'.

I saw an oak on the way back that Caspar David Friedrich couldn't have painted without his critics thinking he'd seen it in a nightmare.

THE CUT OF THE LIGHT

In hot sunlight
at the edge of the wood
a man's shadow cut
dark and sharp
against the path
beside the shadow
of a bracken frond
fine-boned
on mossed oak roots

Silently the marks that no man can read –
dapple, spot and stripe,
hieroglyphs on trunk and limb –
darken
 or vanish
 or are suddenly
a multitude of eyes, a blaze

The wood is a net, a wicker
of giant forms silently burning

 Water is the walls
 Water is the canopy
 Water is the floor

Midsummer:
mast and tiny acorns form
berries redden by dark green leaves
silence deepens
 to the human ear

A multitude of eyes
one blazing pupil

Shadow of a man
Shadow of a bracken frond

Now never now
the season the cycle
bark-year and wheat-year
(we say)
spring wood and summer wood
ring within ring

Beech fountains break
in spray of leaves
Oak walls made of sunlight
stream into the ground

The pattern again, like violent currents frozen in wood, or too slow for the eye to see, where growth has occurred and where it continues – the signature that all living things bear. Van Gogh's spirals, which some people see, and have to take care they are not driven mad.

RED KING'S DREAM

Surely it is nothing, like a song
about nothing. Yet it isn't the sun
that dyes the Lammas woods red
as I ride with my men through the trees.

Words echo among the boughs.
'You shall eat of me no more.'
What does it mean?

I hide what I hear with laughter,
with the gift of a bolt to Tirel.
I am the Red King;
I am the Conqueror's son;
my song's the twang of the arrow,
the rough, sweet voice of men.

Why should I fear nothing,
nothing at all, only
the blood-mist of a fading dream?

I was alone in a chapel,
deep in the woods;
it was richly adorned, as befits
a king and the son of a king.
I approved the purple tapestries
embroidered with legends.

They were old, older
than the Forest.
What did they mean?

Even as I looked they vanished;
the chapel was bare,
on the altar a stag,
which changed into a naked man.
'You shall eat of me no more.'

Whatever it means, let it be lost
in the flight of the arrow,
and the flight of the stag,
the great stag,
my beloved who dies for me,
soaking the earth with his blood.

COMPANY

'Mystery amid a great company of tree.'

1

The wood is full of wounds:

limbs scattered, trunks
twisted and broken,
shells of sapwood standing
when the heart has gone.

And everywhere new growth
heals the wound, a seedling
needles the leaf-mould,
the dead stump bears a living shoot.

2

The wood is full of voices.

But where, where?
(the cuckoo calls),
where is the word that springs new?

3

Figures emerge from the trees,
stag-headed, wreathed with green leaves.

Darkness covers the site –
which light dissolves, opening
cavernous depth.

A sea wind gusts through the grove.

The space fills with sunlight
and shadows, whispering.

Where, where?
At the centre, the naked man,
wearing the holly crown.

In the trees
forked bodies twist and writhe.
Angels and beasts stare down.

Ghost haunts ghost
among the broken pillars,
under the tattered canopy.
The love song fades in the sigh of leaves.

A god with arms outstretched
bows down to the ground.

4

At the edge of the clearing
the great oaks stand,
massively bossed and knarred.

They do not hug the earth
but possess the sky.
Small oaks grow in their shade.

As we approach, they seem
to look at us –
their silence, a language.

WHERE THE GORSE FIRE WAS

A passage between walls
of flowering gorse
that reach high overhead.
Again the warm, spicy smell.
Indescribable.
Through the opening
twisted stems of blackened furze.

A path of white stones –
leached-white –
trodden by ponies
through dry, sandy soil.
On one side the gorse flowers.
On the other, charred limbs
writhe, like black flames.

The Naked Man (said once to have been a gallows on which highwaymen were left to hang until they were skeletons) is held up by a structure of wooden struts. It is grey, almost silver, and deeply lined, split, pitted, wrinkled, peppered with woodworm holes, like gunshot, with concrete in some sockets; partially hollow, exposing brown rotten wood, its broken-off trunk like a long curving neck, from a short distance, like a horse rearing up out of the bracken. Like some very ancient being, kept upright artificially, and only just held together, but standing on a mound of sweet grass, brambles, daisies and birdsfoot trefoil.

The sun was coming out from dark blue clouds threatening storm as I approached it along a grass track beside woods of horse-chestnut, oak and pine, with wide heath on the other side, bare except for bracken, clumps of gorse and a few isolated Scots pine stretching far away, chimneys of Marchwood power station visible above trees and ponies on a distant skyline.

PRESENT

The boy with a fishing rod
follows the river upstream
in April, among the windflowers.

The young man lies hidden
in a net of light and shadow,
naked, with his love.

The father walks under the trees
with his son,
who is laughing on his back.

And we call this *now*,
when the man stands still
in the woods in summer,
on leaves that we say are dead.

an unknown way of being

WINDLESS LEAF-FALL, WITH EMILY

Oak leaves and beech leaves
fall round us,
spiralling down,
creeping through the air.

Yellow leaves and bracken fronds
catch the sun.
We smell decay
and the earth-side of mosses.

Puffballs, acorns, mast,
chestnuts, fircones, fern,
leached flints – already
they are half-imaginary –

objects for her art class:
colours that tell a story,
shapes that make a world.

We find a small, clear pool
of water on a bed
of dead, golden-brown leaves.

And when we are lost
we meet an old man carrying
a full sack on his back
who shows us the way,

downhill, on a path
where we step carefully
over twisted roots;

but I see us dancing –
late brimstones turning
round and round.

Leaf falls lightly on leaf.

Blackened furze/white stones. A passage between walls of flowering gorse reaching high over my head, with its indescribable warm spicy smell, opening on the site of a gorse fire – blackened, strenuously twisted branches and stems, the surviving prickles scorched brown.

None of the greater, and few of the lesser trees are without a maim, many of them more fearful than diseased or ivy-strangled limbs. A great oak stripped of bark, another, split in two, resting forked branches on the ground, like a figure bowing. A recumbent, carved beech torso, as if the tree were giant effigy and bier. An enormous, rotten beech stump, streaked black and green, fungoid, the touchwood interior riddled with beetle and crumbly as cheese, apparently long-dead, but with a living branch.

IN STILLNESS

After the hurricane that smashed
through the ancient beechwood,
uprooting trees that the foresters
lopped and quartered, leaving
silvery naked torsos, and walls
of roots and pebbled clay,
two brown ponies wander in,
and feed in the new spaces,
chewing, chomping, snorting
head to head, over
the grassy floor – until
a twig snaps and they look up,
each with a green moustache
at the corners of its mouth.

ALMOST NOTHING

She returns with the wind:
spirit-wolf,
grey between gorse.

Tongueless she howls with the gust,
moans in the hollow tree.
Formless she hunts for form.

What is too little to call to her?
A beetle-case sings of hope.
An empty shell harbours her desire.

She returns with the word
on the last human tongue –

almost nothing,
a body which the air
shapes from dust, blowing
under the wolf's-head tree.

THE NAKED MAN

(*With despair, as always
at the beginning*)

1

To begin, to begin again –

 Nothing
could be more dead than this tree.
It was once, they say, an oak,
and once, when the highway
crossed the rutted heath,
a gallows.

 Now it stands
naked to winds from the sea,
stripped of the final skin,
bone of the bone.

A broken off trunk,
with concrete in empty sockets

 I think it is like
an ancient being
held together and kept up
by a wooden scaffold.

2

Dead, the riven tree
rears up like a horse
with curving neck leaping
from the bracken –

a silver horse
among the brown ponies
grazing the open forest.

Dark blue clouds approach
threatening storm, gorse
and a few Scots pines stretch far
to the south.

The dead tree bends its silver neck.

3

To begin, to begin again
to make an opening –

What obstructs us but fear?
We must give what we have to give
body and soul.

You see the large, blind eyes.
He is there, the ancient wounded one
imprisoned at the core.

What emerges when you cut down
stands free of you,
and sets you free.

What is poetry? What is sculpture? Surely, in each case, the imagination is not only a mental faculty, but rooted in the whole body with its connections to the world. Is it possible, though, that sculptor and poet can somehow work together, not in order to illustrate each other's work, but learning from each other how to go further, each in his way? I think of poetry as an art of seeing, an art by which, in my blindness, I learn to see. As a poet I work at the edge of sight, which is the edge of meaning and of language. It is the edge between the little I know and what may be chaos or could be a greater order. Here I waste effort, stumbling in the dark; here, sometimes, I find an opening. This is one of the ways in which I think about poetry, and it seems to have something in common with Lee Grandjean's sense, as he begins a new work, that he is cutting into the void. Looking at his completed sculptures, it is hard for me to realize that he too works in the dark, and always starts at the edge, where he may fail. With time, of course, in the light of completed work, an artist will evolve ways of thinking about his art, but however well defined the thinking may be, he is always, in the act of making, at the edge of chaos.

There is another, complementary way in which I think about poetry. From the time of my first book of poems, *Soliloquies of a Chalk Giant*, 1974, I have thought of myself as working from what I call a 'ground'. By this I mean a place with strong personal associations, but also charged with ancestral and social experience, together with the natural and historical processes that have made it. For me, knowledge of a ground is primarily felt, but I also seek to know the 'materials' – geology, ecology, history, and so on – in depth, and with a view to factual accuracy. In 1978, after the publication of *Solent Shore*, in which my ground had been the south coast, I turned my attention to the adjoining New Forest area, where I had grown up, and where I still felt I belonged. Then, for the sheer pleasure of it, and in order to renew my sense of touch, I again walked and cycled in the Forest, recording impressions and ideas in my journal, which I thought would be useful for the poems I hoped to write. For personal reasons, work on the project was halted before I could make use of the notes, but after I had met Lee Grandjean in 1981, at Winchester School of Art, where he had a sculpture fellowship and I was creative writing fellow, the idea was revived, but in a new form.

The idea of our one day working together occurred to both of us early on, after we had formed a close friendship, based in part on our recognition of common imaginative aims, with the excitement of their being expressed through different arts. The idea did not develop fully, however, until we were both free to give it our sustained attention, in the late 1980s. By then, as well as realizing that we were being drawn independently to similar themes, it was even clearer to us that we were, in any case, embarking on similar explorations, which were centrally concerned with tree-images.

As Peter Fuller implied, when he described Lee Grandjean's work as containing 'echoes of the great Gothic wood-carvers of East Anglia', Grandjean is a sculptor who makes images. However current fashions may interpret the art of sculpture, image-making has always been (and still is) one of its primary functions world-wide. But, whereas in a traditional culture the sculptor derives his images from an established iconography, the modern image-maker has to be essentially exploratory, finding in personal feeling and emotion new shapes of meaning. Of course, no artist starts with nothing, as if from the dawn of creation, and one important aspect of modernism is the transformation of traditional images, with a view to making them new. During the last decade, Lee Grandjean has explored images of containment and release, of leaping or dancing figures and flames and organic forms, and of arched and cruciform objects, which are tense with the connection between opposing forces. All these are traditional precisely in the sense that they are ancient symbols shaped anew, to realize a vision alive to the present; and all are now comprehended and being developed within his tree-images, which, in exploring new relationships, also express the human situation between organic and man-made rhythms and forms, between nature and the city.

We were drawn together partly because we are both image-makers, and both exploratory in our methods and by virtue of our need to discover new possibilities of connection. This is an emotional need, rooted in the artist's being, before it issues in theory, if it ever does. As I apprehend it, the need now is to explore relationships in different spheres and at different levels: between man and nature, body and spirit, the one and the many, man and woman, and between male and female elements in the individual psyche. It is a need arising from the shattering of the human image, the image of man made in the likeness of God, in the aftermath of which explosion we all live. I do not claim to speak for Lee Grandjean here, but in speaking for myself, I am voicing what I have learned from his work, as well as from my own practice.

As I understand it, the edge is within the self, between the self and other people, and between the self and any ground of ultimate meaning.

During the 1980s, both Lee Grandjean and I were attracted to the tree both as a symbol and a source of imagery, and the attraction was inspired by a primary love of trees and of wood. It was natural, therefore, that when we were ready to collaborate on a project involving sculpture and drawing and poetry and prose, we should focus on the tree. At this point, I went back to my journal and extracted the passages I had written about the New Forest ten years before, and sent copies of them to Grandjean. Reading these with a sculptor's eye, he found in them words or groups of words which had, for him, sculptural potential, suggestions of form or shape, or of relationships between forms or shapes, which he proceeded to explore, at first usually through drawings, which are themselves dynamic works of art, as well as being movements towards sculptural rhythms and forms.

The collaboration involves more or less complex forms of communication between sculptures and drawings, and poems and prose passages, which do not diminish the integrity of the different arts or of the individual works. It was absolutely not our intention to illustrate each other's work, and the collaboration could not succeed unless we were independent of one another. For a time, I found writing difficult, precisely because Grandjean's images were so strong, and were coming between me and my ground; but the difficulty was part of the creative process, and helped me to see what I had to do. *Their Silence a Language* makes connections between sculptural and poetic images, and there were occasions when I responded to a particular sculpture with a poem, but, for the most part, the connections between the images are less direct, and made at a deeper level. Sometimes I saw my material in the light of Grandjean's exploratory image-making, which suggested new approaches to it; and sometimes I wrote independently of both his work and my original notes. One difference of emphasis between us is that I am concerned specifically with the New Forest, as well as sharing the concern with tree-images, which in his case does not involve the history, ecology and topography of the Forest. On occasions his emphasis has drawn my attention to elements in my writing that I might otherwise have overlooked, and there are poems belonging to the collaboration, particularly 'Steps' and, to a lesser degree, 'The Naked Man', in which I have incorporated his words, so that he has shared in their making.

Our creative interaction in *Their Silence a Language* has taken several forms, and cannot be described exhaustively, largely because it is imaginative rather than rationally planned and controlled. The tree

itself is an inexhaustible symbol, hospitable to many different uses and meanings, and endlessly generative, in living and dead cultures. And exploratory art and thought is by definition open, belonging to the edge – the artist who knows exactly what he or she has to say or make before saying or making it is not an explorer. But if this seems to suggest that exploration is an end in itself, with an interest in never arriving anywhere, it must be remembered that all images always fall short of ultimate reality. According to this view, every image is a stage or a step towards the real, and towards defining the artist's vision, by which he, too, learns to see.

For me, part of the excitement of our collaboration was in learning more about a sculptor's apprehension of rhythm and form. Lee Grandjean is an artist with an intimate knowledge of his materials, whether wood or stone or bronze, but his main concern is not with truth to materials, but with shaping an imaginative vision in terms of sculptural objects and forms. The vision is dramatic, questing, not to be limited by any definition of theme – that critical word which, surely, no poet has in mind while writing a poem, and no sculptor while making a sculpture. Grandjean's work may however be said to be about participation, or the tension and possibilities of the human situation between nature and the man-made world; but if participation is a theme, it is first an experience, either known or desired. Thus, in Grandjean's sculptures incorporating elements of the arch and the cross, his elongated figure based on the human body (which is one of his principal motifs) is stretched taut, and makes a bridge, between forms symbolizing organic and mechanical orders of being. The spectator (or, I would say, the participant) is not presented with a simple conflict between worlds – indeed, the strong celebratory impulse in Grandjean's work extends to the city and mechanical effort as well as embracing nature. He works from and appeals to sensation and emotion, from the physical experience of being human; it is from this that he shapes a vision which explores metaphysical meaning, incarnate in images of figures walking up steps or dancing or standing upright between earth and sky. In exploring through sculpture what it feels like to be alive today, he explores what our situation as divided yet related and connecting beings means, and what we are capable of becoming. There is, of course, dread and anxiety in this, as well as pleasure; the present itself is an edge, which shows itself in the uncut wood, or the void of the blank page.

Writing poetry is, of course, different from making sculpture, however much poet and sculptor may use a common language of image and rhythm and form and object. Nevertheless, the poet too may have a

physical relationship with his materials, with words and with the things and processes they name, and an imagination rooted in being, that is equivalent to the sculptor's shaping vision and touch. I found and loved an elemental hardness and clarity in Richard Jefferies's prose, long before I learnt to value the imagist root of modern poetry, or read Donald Davie's *Ezra Pound: Poet as Sculptor*, in which he discusses analogies between carving and ways of using poetic language and form. From early on, I had a preference for a kind of poetry that is 'cut' and shaped, resulting in a verbal object, as distinct from an act of self-expression, and corresponding to the otherness of reality bodied against us. The kind of presence I admire, in sculpture and in poetry, is inseparable from the silence in which it speaks, and which it makes us aware of.

Collaboration between artists should be exciting and mutually nourishing for those involved in it. So it is (for it does not end with the book) with *Their Silence a Language*. But what is the spectator and reader expected to derive from the work? Pleasure, of course, from the individual sculptures and drawings and poems and pieces of prose, and from the overall shape of the project. But also the excitement of being a participant, of entering a work that may be described by analogy with a wood, with coverts and thickets and clearings, with ancient trees and new growths; a wood which there are many ways in and through, ways for the participating imagination to discover, and ways for it to half-create; but a wood in which mystery is integral to its being, and which therefore cannot be exhausted.

JEREMY HOOKER

This is a revised version of an essay which was first published in *Modern Painters*, Volume 4, Number 2, Summer 1991.